Tales fro

UNBOUND
PATH

ISBN:
978-1-913590-89-5 (Paperback)
978-1-913590-90-1 (ebook)

Cover design by Lynda Mangoro.

The Unbound Press
www.theunboundpress.com

Hey unbound one!

Welcome to this magical book brought to you by The Unbound Press.

At The Unbound Press, we believe that when women write freely from the fullest expression of who they are, it can't help but activate a feeling of deep connection and transformation in others. When we come together, we become more and we're changing the world, one book at a time!

This book has been carefully crafted by both the author and publisher with the intention of inspiring you to move ever more deeply into who you truly are.

We hope that this book helps you to connect with your Unbound Self and that you feel called to pass it on to others who want to live a more fully expressed life.

With much love,

Nicola Humber

Founder of The Unbound Press
www.theunboundpress.com

CONTENTS

ÍNTRODUCTION

What does it mean to walk an unbound path? To unbind from old expectations of who and how you should be in the world and go your own, unique way?

That's the question we asked the contributors to this book at the end of 2022.

And it's a question I'm endlessly curious about; both for myself personally and for us collectively. Because I believe these times are calling for us to be (more) unbound; that the only way out of the turmoil we're experiencing is through each of us waking up to the magnificent, unbound beings we truly are. (And yes, you ARE magnificent, magical soul – even if you don't quite believe it!)

My own relationship with 'unbound' began back in 2014. I was working through Danielle LaPorte's Desire Map process and was tuning into my Core Desired Feelings.

How did I want to feel?

Immediately the word 'freedom' came to mind. But it didn't quite light me up.

Of course, I wanted to experience freedom. Who wouldn't? But when I tuned into that quality, I couldn't FEEL it in my body.

So, as the word witch I am, I turned to the thesaurus (and yes, I actually had a physical copy of a thesaurus at the time). I flicked to 'free' to see what other words might catch my attention.

And then I saw it: UNBOUND.

Immediately I felt a deep sense of resonance in my body.

Unbound.
The suggestion, the knowing, that something had previously been bound, restricted, held down. And now it was being freed, released, liberated.
Yes! That described what I desired (and what I'd started the process of experiencing over the past few years) perfectly.

You see, for most of my life I'd been attached to the identity of the Good Girl. I'd done what was expected of me – getting a good education, a good job, doing 'well' and presenting the image of a 'successful' woman.

But on the inside my soul had been screaming.

'No! This is NOT your path, Nicola. There's another way. And I can't tell you exactly what that is right now. You'll have to trust me. Can you trust me?'

For years I ignored my soul's calling. And then I got to the point where I had to listen.

I couldn't carry on sitting in an office every day, doing a job I hated and pretending that everything was okay. It wasn't.

So, in 2009 I took my first step onto what I now know as the unbound path. I left my job in finance to retrain as a coach and hypnotherapist. And somehow that first step has led me to where I am now – running a publishing company and holding space for the most incredible community of creative women. WTAF??

Magic happens when we trust enough to take that first step.

What I've learned is you don't need to know what the whole path will look like.

In fact, you probably can't even imagine where it will take you. Because the nature of the unbound path is that it takes you BEYOND.

Beyond what has been.

Beyond the stories that have held you back.

Beyond the old identities that don't represent a fraction of who you truly are.
Beyond.

Beyond.

Beyond.

I'm so excited for you to meet the women who have contributed their unbound tales to this book. The intention is that as you read, their words will serve as an activation, reminding you, deep down, of who you are and what you came here to be.

And maybe that will lead to you contributing to the next edition of Tales from the Unbound Path?

Now that would be something…

Are you ready, magical one?

Nicola x

Founder of The Unbound Press

THE THREAT OF THE UNBOUND WOMEN

By Charley Alcock

The circle of women.
Around the crackling fire, in the lush green forest, howling at the moon.
The priestesses, the artists, the writers and poets weaving their words into spells.
Weaving their spells into life.

Dancing and cackling as they share their stories and sing their song.
The wisdom of the ancestors runs deep in their bones.

The unbound wild woman is so deeply rooted in her beingness and magic.
She shocks and repulses, entices and hypnotises.
She is who she is. Without apology.

She is free.
She is me.
Maybe she is you?

Before society got a hold of her.
Told her to be a good girl.
To do as she is told.
To not rock the boat.
To keep everyone happy.

To take care of everyone else's needs.
Until she abandons herself and severs her wild.
Domesticated.

A good daughter, mother and wife.
A sentence to the life.
Disconnected.
A group of women, considered a threat to society.
Maybe they're witches?
Sharing stories of wisdom from the earth, the sun, the stars, the moon.

The power of our cycles.
The waxing and waning.
The blood from our wombs.
Offered to the earth.
A deep honouring of our crimson elixir.

Before we were shamed for feeding our baby their milk from our bare breast.
'Not where anyone can see you, please, Madam'
Because heaven forbid a woman has a nipple!
Or a mind of her own.

Or chooses not to be a mother to another.
How bold.
For knowing what she wants.
Imagine!

She creates books and art and beauty in the world.
It comes from her soul.
Created with grief and pain.
Created with love and fire.

What a threat to society she would be.
If she knew the power of being connected to her body.
Her unique and beautiful body.
Not a trend to keep up with.

A sacred vessel to honour and adore.

To allow for pleasure.
Her softness and sensuality are not here to be shamed.
They are here to be celebrated.

She is far too holy for dick pics and 'Hey, how are you?'
She is a majestic magical creature. Wild and free.
She can birth new galaxies and dies new deaths each month.
She is love, power and wisdom.
She is you.
I LOVE YOU.

*Whilst I have used the word 'woman' and the pronouns 'she' and 'her', these are my preferred pronouns and this is for all unbound humans. I love you.

About Charley Alcock

Charley Alcock is a lover of dogs, naps and sunsets. Five years ago, she followed her heart to live by the sea in Dorset.

Charley is a wild woman and modern-day priestess with a Northern accent, and an Energy Healer, Soul Guide and Writer. She is a Reiki Master, works with the Akashic Records, offers 1:1 journeys and runs sacred circles, writing circles and workshops and mentorships.

Much of Charley's work is focused on the heart and reconnection to peace, wisdom and power. Returning to the ancient ways. Reconnecting with the Earth, heart, energy, soul, our cyclical nature and each other. Bringing together the divine and humanness with love.

As an unconventional weirdo, Charley naturally took the unbound path and continues to unravel.

If you want to connect with Charley you can find her over on Instagram: https://www.instagram.com/charleyalcock

She would love to see you there.

THE HERETIC'S JOURNEY: FROM OUTCAST TO LEADER

By Kelly Moss

Shortly after my thirtieth birthday, I gave away all my belongings, left frantic messages from friends and family unanswered, and went for a walk.

My estrangement was intentional, but traumatic. I had recently uncovered memories of childhood sexual abuse and was not well-received in bringing the family secret to light.

Still in shock about the discovery myself, it now seemed the whole world was against me. Even my therapist, who knew my pain intimately, was appalled that I hadn't called my mother on her birthday.

This wasn't the first time the healthcare industry had proven to be untrustworthy – I had also been scarred by a patient privacy violation in my teens. Having experienced one betrayal after another as a result of speaking my truth, I had never felt more discouraged or alone.

When I burned out from my high-stress job and became unable to work, my feeling of social disconnection grew exponentially. I was disgusted that I'd had to make myself sick earning the right to live, especially when I'd never had a childhood to begin with.

What else was there to do, but go out and play?

I had no plan, except to leave civilization. I craved an escape from the money, media and pretense that had dulled my relationships until that point. Fully committed to autonomy, I would no longer play the role of the loyal employee, the grateful daughter, or the compliant patient.

I gave away tens of thousands of dollars I had inherited from my grandmother, wanting nothing more to do with money. If the birds and trees could give and receive freely without expectation, why couldn't I? I was desperate enough for a meaningful life to give it a shot.

The journey began in Oakland, California. I walked for miles through the city, talking to people along the way. The first day, I was invited to a front yard barbecue. I enjoyed many incredible synchronicities, finding that food and other things often showed up exactly when needed.

In my family, every gift came at the price of my dignity. I was amazed to find that perfect strangers were kinder to me than my own blood. I started to gain a sense of safety in the world that I had never known before.

I also appreciated how straightforward the people I met were, happy to tell me exactly what they thought of me to my face. Compared to the world I had come from, this was refreshing. I had always been blunt and found new confidence in my no-BS communication style.

Wanting more than anything for nature to reclaim the hostile, sensory-violating cityscape, my path led me to radical environmentalism and the fight for indigenous sovereignty. The wilderness grew inside of me as I fought for the wilderness without, and my voice grew stronger as I made a habit of

speaking the words in my heart.

A few times, I was allowed to sleep in someone's backyard after having knocked on their front door a total stranger. I was amazed at how generous people were when I was honest about my situation. Of course, this wasn't always the case.

Usually, I slept behind the bushes in front of churches, or in the forest. I told myself that I was safe so that I could fall asleep. I wasn't sure whether I was lying to myself, reasoning that if I wasn't always safe, at least I was free.

Within a year of beginning my journey, I was pregnant.

Holding the trauma of rejection from my family and society and the crushing weight of eco-despair, I was suicidally depressed. The pregnancy presented a divine invitation to take care of myself, even if there seemed no real point to life. I was stubborn enough to need it.

Although I had projected onto the wild freedom from patriarchy and the evils of civilization, I had to admit that the primitive utopia I longed for did not exist, and that my no-limits lifestyle was wreaking more havoc on my nervous system than the working world.

I had discovered that I didn't need money to survive, and that the universe would always have my back – but after everything I'd been through on the streets, and knowing what was to come with motherhood, I wanted financial security.

Determined not to sacrifice the freedom I had gained, the next few years were a test of resourcefulness.

I started making jewelry, weaving my trauma, hopes and dreams into each piece of gold wire. I set the intention of

earning $60 an hour with my business, and I did. My daughter and I traveled internationally as pet sitters. I diligently saved up 90% of my income and bought land.

When my daughter was three, I started a digital marketing agency for acupuncturists, who had helped me heal. I taught online classes on patient privacy compliance so that their patients could safely share their stories – a privilege I had been robbed of many times.

I felt fulfilled serving an industry I cared about and making meaningful change, while maintaining the freedom to raise my own child, heal and travel. And after decades of underearning due to associating money with my father's abuse, I finally felt capable of building wealth.

Not to mention, I was literally being paid to tell my story – what delicious cosmic justice!

I had gone from feeling like an outcast to redefining myself as a leader. Having set new standards for my life, the world had risen to meet them. I was amazed at the power of my own desires and intentions.

I now support other entrepreneurs on their own Heretic's Journey, from speaking truth to embodying leadership. Overcoming shame and owning our voices, we are building a new world with the powerful messages our stories hold.

Although I never got the acceptance from society that I craved, I found by walking away that I could create it for myself. In inviting others to walk with me, I found the belonging, justice and abundance I had long been searching for.

About Kelly Moss

Kelly Moss is a speaker, author and coach living in Mexico with her daughter, and a self-taught artist and online content creator. With a passion for writing, comedy and improvisational songwriting, Kelly has always loved to play with words. She once threw out dozens of journals, secretly wishing that they would be discovered and published. That didn't happen, so Kelly is now piecing her story and insights together to share with the world in her upcoming book. Through her business, The Second Childhood, she supports online coaches, healers, consultants and other purpose-driven entrepreneurs in activating their leadership through language, using a combination of Human Design, voice analysis, writing, and channeling. In Kelly's intuitively attuned presence, her clients find the perfect words – and the courage – to communicate the value of their work and articulate potent messages that ignite transformation in their communities.

You can find out more about Kelly's work here:
bio.site/kellymoss

FROM FEAR TO FREEDOM

By Alison Shaloe

'Unbound, unbound, forever unbound,' those are the words I kept hearing as I started to work with The Unbound Press. I realised with the writing process that I was being unbound. Unbound from who I thought I was, unbound from all the social conditioning and unbound from my self-limiting beliefs of not feeling good enough, worthy enough or loved enough. I felt that by writing my book, I would be judged, that I would lose my reputation as a midwife and potentially lose my midwifery registration. I worried that people would think I was crazy because I was not following the path that people expected of me. These fears were very real in the writing process.

Writing my book made me feel like I was breaking out of the mould and becoming all that I was meant to be, all that my soul desired and all that I believed I could be. The writing process helped me to step out of fear and into self-love, to step out of fear and into courage. I had to find the courage to trust my inner voice when it didn't make any sense. I had to trust the guidance that I received even though I felt confused. When I think of being unbound, it was like I had been wrapped in layers of cloth that were unbinding throughout the writing process. When I wrote my book, it was not the book I was planning to write but it was what wanted to unfold. Throughout the writing process, I came to realise I was becoming unbound from the shackles that tied me to my conscious mind, to unresolved emotions and to the generational wounds from a society with patriarchal values. I was doing this to shine a light on the impact of being silenced, of staying small to fit in or staying quiet for fear of upsetting others or not being accepted. For me the fear was

real, and I was fortunate to have a healing modality that I used when the fear came up for me.

Havening Techniques® is a relatively new psychosensory healing modality that helped me to overcome so much during this process. It works by using touch on various parts of the body which in turn generates delta brain waves. As a result, there are changes to the neurochemistry of the brain so that stress chemicals like cortisol and adrenaline decrease and feel-good hormones like oxytocin and dopamine increase, helping to gain a sense of calm and peacefulness. So, I would begin by getting a sense of the fear I was feeling and score it with a number from 0 to 10 (zero being not distressing at all and 10 being very distressed). I would then cross my arms over my chest and stroke from my shoulders to my elbows, stroke my face or rub the palms of my hands together. As I did this, I would distract myself by imagining that I was walking in a beautiful place in nature. I would close my eyes and imagine walking 20 steps on a pathway. I would then name 10 things that I could see, sense, hear or feel in my imagination then I would count the trees and watch the birds. I would imagine two people ahead of me who were playing catch and I would watch the ball by keeping my head still and physically move my eyes from left to right a few times. Then I would check the score again and if it was 5 or above, I would imagine I was walking through a rose garden just like the one in Regents Park in London. I would take 20 steps in the garden, I would count the roses, name the colours and give them names.

I would continue along the path, moving my eyes to the left and then to the right to see one rosebush on the left and one rosebush on the right several times. Then I would check the score again and repeat if the score was between 5 and 10. Once it was lower, I did affirmations whilst Havening, which helped to calm the part of my brain where the fear

was being felt. I would say, 'Even though I feel some fear, I am safe, peaceful and calm. I am safe, peaceful and calm. Even though I feel afraid about taking my book into the world, I am safe. It is safe to take my book into the world. What if my book is just what the world needs? What if my book will make a difference to people's lives? If it makes a difference to people's lives, then I will be making a difference in the world and fulfilling my mission to heal the wounds of the mother and to help to birth the new highly-evolved souls who wish to be born. This will make a better world for everyone.' Then I would finish with, 'I am courageous, I am capable, I am fearless, I am fulfilling my life purpose.'

These affirmations would be a reminder of why I was writing the book and as time went by, I understood the importance of what I was writing. I had to get out of my own way and just allow it to come through. Now, my book is out in the world and I am on the other side of the fear and it feels great! I am proud of my achievement and all that I had to overcome through the process. This is a shout out to all of you who are reading this and to any aspiring authors. Follow your heart, trust your instincts even when you don't know where you are being led. Just show up in your life, spread love wherever you go and it will ripple out into the world. The unbound path is not an easy one but it's so worth it! So, be unbound, unbound, forever unbound, then allow the magic to unfold in your life.

About Alison Shaloe

Alison Shaloe is a registered midwife and lactation consultant in the UK. She specialises in supporting women with breastfeeding, tongue-tie and birth trauma. She is also a spiritual healer, spirit baby intuitive and author of *Baby Talk to Me: Spirit Baby Messages for the Journey to Motherhood*.

Alison has supported thousands of women during pregnancy and birth and in the postnatal period. She is passionate about supporting and empowering women and assisting them on their journey to motherhood physically, emotionally and spiritually. She also supports women on their conception journey and after pregnancy and birth loss. It is part of her soul mission to heal the wounds of the mother and the mothers before them, to enable the highly-evolved souls to be born into a world with less fear, pain and generational trauma.

You can contact Alison through her website:
www.alisonshaloe.com

ℬECOMING UNBOUND

By Becky Handley

As I began my unbound journey, I must admit that a part of me was scared.

I had spent so much of my life bound. Bound to who I thought I should be. Bound to being a 'nice girl'. Bound at my hands, my lips sewed shut.

My voice trapped inside, so certain that everyone was right with the labels they bestowed upon me. My voice trapped in feelings of unworthiness and feelings that I was only getting what I deserved.

Daily taunts of 'ugly' and 'freak' had been my life during my formative childhood years. We are taught that words aren't supposed to hurt because they don't cause the physical pain which comes when someone hurls something at you.

Believe me when I say, words cause immense amounts of pain. Words cause people to hate who they are and what they look like. Words cause people to have a constant sick feeling in their stomachs. Words cause people to hurt themselves. Words cause people to give up.

Words cause people to feel like there is something wrong with the fact that they exist at all.

And they do it all without them leaving a mark on you.

I did not realise that to truly live an unbound life I would have to untwine myself from all these old labels that no longer fit,

that never fit! I did not realise I would have to untwine myself from all the stories from my past in which I allowed myself to be treated like something less than others. Something not even human. I did not realise I would have to untwine myself from all the stories I had told myself – that I was a bad person, that I was in the wrong, that I deserved what I got, that I was unworthy, that I was unlovable.

And I did not realise how much this would scare me.

I understand that to untwine yourself from so much pain should feel like a weight being lifted but it was all I had known. I did not know how to thrive, only to survive. I did not know who would be waiting on the other side.

Who was the Becky that wasn't scared all the time?

Who was the Becky who proudly said, 'This is me and it's okay if you don't like me because I do'?

Who was the Becky who went for what she truly desired and stopped living a life she thought she 'should' live?

I did not know the answer to these questions and that scared me. Thankfully, the thought of continuing on how I was scared me even more because I knew I could not live in a world where I had to continue to silence my voice, silence my soul, silence my magick, silence my power. I knew I could not continue to live bound to a version of myself that was not me at all.

Crying and screaming for release, it was either letting her free or giving up. End it all with none of the romance you see in the movies. Just another person gone too soon, their story untold. Nothing ever getting better because I would not be here to make it better.

That could not be my end. I was beginning to see my own power, my own desires. I was beginning to see that I could change the world. Maybe no-one else's, but I could definitely change my own. I did not need to live a life I did not want. I did not need to keep myself quiet and small. I did not need to keep myself bound and my lips sewed shut.

I could be free.

As I continue to untwine myself from all that has bound me for so many years, I have found that I like who I am. And yes, I am rather wonderfully weird and I am a glorious freak. Those labels they got right and I wear them with pride.

I still have so many lessons to unlearn. I do not need everyone to like me. I do not always have to be nice and positive, particularly to those who are being cruel. I am allowed to show how I am really feeling and I am allowed to be angry. I am allowed to be sad. I am allowed to scream and shout. I am allowed to be impatient. I am allowed to be gloriously happy. I am allowed to celebrate all that I am. I am allowed to be.

I am beginning my unbound life with a simple realisation that is, all I have to do – I have to be. To be unbound, I just have to be me. My beautiful, true self. Be ready to learn, to grow, to change as the days, months and years pass but always carry my unique creative energy with me.

Always take me with me and all will be magickal.

All will be unbound.

About Becky Handley

Becky Handley is a writer and artist based in Derbyshire. Her art crosses over many borders from film to abstract painting to photography and, of course, to writing. Her writing has been published on online platforms such as 'Dear Damsels' and 'Hundred Heroines.' In June 2021, she self-published a book of her poetry and art which she titled *I Want to Be Here* as it documents her journey with her mental health, through the darkness towards the light.

Over the past two years, Becky has found her spirituality and her authentic self and voice, leading to her truly thriving for the first time within her creative work and within her own skin. She is truly becoming unbound.

If you would like to know more about Becky, please head to her Instagram: @beckyhandleyart

ƒWAKENING

By Karen Marshall

Becoming unbound is all about freeing yourself of all that does not resonate; that does not serve your highest good. The emphasis being on YOUR highest good and nobody else's. The freedom you feel by unbinding yourself from others' expectations and the pressure you have imposed on yourself creates a flow. It allows for free-flowing energy to permeate your soul, expanding and spilling out into all areas of your life.

By releasing all that blocks and stagnates the flow, releasing the fear and shining a light for others along the way, it allows for them to do the same, in their unique, unbound way. For we are all one. It's the difference between skipping along the path of life, happily swinging a lantern as you go, or dragging your heels along it, struggling to read a map drawn by someone else, without a torch.

It realigns you to your true self, to embodying who you were meant to be during this incarnation on our beloved Mother Earth.

It also allows us all to take that step to truly becoming unbound. For some it's the first step and for some it's the last. There are also those of us who have forgotten how it feels, who started off feeling they were unbound and free, only to be crushed and made to bury the memories.

As we move forwards towards Earth's next phase of evolution, together as an unbound community of souls, each one of us is responsible for resetting the course of our energetic flow so we can evolve as a whole. Each person playing their part,

each handing over their unique piece of the puzzle, their link or hand in the circle of unity and friendship.

I have had to let go of so many things on my journey to becoming unbound. A lot of challenges had to be overcome and a miracle had to be birthed.

I am, however, getting there. I'm remembering what I'm here to do and putting it all into action. I'm either letting go of the fear, or feeling it and jumping anyway. I recently met my unbound self during a meditation and it had a profound effect on me.

I had initially seen and felt myself swimming under water with dolphins and then saw myself emerge and sit on a rock by the water's edge with my unbound self, the spirit of the book I'm to write. When I reflected on it later, whilst waiting for my son to fall asleep, I saw myself still swimming under the ocean, whilst an almost identical version of me sat on the rock. She was dipping her feet in the water, still wet from her swim and glistening peacefully in the sunlight.

I was puzzled for a moment, as I hadn't expected the spirit of my book to be me, and then I heard her speak:

'I am the unbound version of you.

This is how it feels and looks to be truly unbound.

You are so close, dear one, you have but threads to release. You have dressed them up as gold threads, but the threads were and still are binding you to fear.

Fear of all that binds you; ties you to outdated beliefs imposed on you by others.

Fear of financial freedom.

Fear of completely speaking your truth, of stepping forward, unbound and free for all to see and learn from.

You can almost touch the surface. You can see the sunlight and the dolphins and feel the support and healing they give you, but I am at one with the water.

I am the dolphin and the turtle.

I am the water dragon and the pearl, which you seek down in the depths. I am the sunlight. I breathe clearer air than you.

Once you are truly unbound, there'll be nothing to stop you.

You will be the free, unbound spirit you were always meant to be.'

I was then guided to open up my notebook, to a page which listed all I had to let go of. It seems there is yet more to let go of, so I can let it flow like the waters I was swimming in.

About Karen Marshall

Karen is a soul whisperer, energy healer, fertility support coach and Reiki Master. She nurtures and empowers people on their journeys to self-mastery to becoming who they were born to be. She specialises in supporting older women on their journeys to motherhood and is writing a book about her own unique experience.

Although born in the UK, Karen grew up in Brazil, which she feels has influenced her love of colour, nature and animals.

She currently lives in the UK with her 3-year-old old son and their furry companions.

You can find Karen on Instagram: @gatewaytothesoul

The Unbound Path to Self as Love

By Babita Gill

So often we walk a path that has been paved by another. We walk it for as long as our soul, our true nature will allow. Some days the status quo will have us wear masks, be compliant, to conform. To keep the peace, we might deny aspects of self. For the sake of 'normality' we might find ourselves hiding our magic. And then comes the time when the soul declares this is no longer good enough; it might never fully have agreed to the chosen path in the first place, if at all. And so you are called to another way. To live from the heart, led by soul-aligned actions. This way of moving in the world requires moments of great courage. Sometimes great moments of courage will save you from having a lifetime of mediocrity and self-denial. It asks you to walk the path of truth. This path might need you to be the first to carve and pave it. To be the initiator of something significant. The fires of alchemy might burn away that which no longer serves and the rest will turn to gold when divine time makes it so. Walking a golden path home to yourself. To love. To yourself as love. This feels so nourishing and enriching. It feels this way because it is. When you find what you love you will see yourself in the form it takes. Part of you shaped by the place it has in your life.

My love of words has almost always been transformative and heart expanding. It has revived me from sleeping states and resuscitated those parts thought long dead. Sometimes to read, to feel words, I feel the safety and connection of something much bigger than I. A holding and container that allows me to let go. And this is one of many reasons I

write too, why I create on the blank spaces something which might feel as though it is etched on the fabric of every soul. I am invested in the recovery and restoration of even the most lost and forgotten parts. To be unbound and boundless. To connect hearts. To call forward truths which are awaiting the resonance of something undeniable before they dare to be uttered out loud. Being both invited and inviting of the possibilities the Great Creator lit in my heart. To be an alchemist in the process of transformation first for myself then in the ripple effect, others.

Self-love creates a full cup and from this fullness comes devotion and service. And so with courage, trusting and surrendering, I declare I am unbound in all the ways a fully human and divine being can be unbound. Calling forward connection to self as love. To alignment and expression of all facets of self in order to move in this world from a place of wholeness. To show up fully for myself and as an example of what is possible for any other too. To live this way feels so intrinsically linked to why any soul might have chosen the human experience. For when you are enriched by the highest highs and the lowest lows then life's fullest flavours are available to nourish your body mind and soul. No more is it acceptable to take crumbs from the table of another. For you will feast on what you yourself have grown and gathered. Consuming only that which feeds the most starved parts of you. So the restoration of you begins from the inside out. This is the unbound path of infinite abundant flow and this is the pathway to our own growth. This is the dance of a thousand wishes placed in the hands of ancestors who came before and declarations in the hearts of those yet to come. Find the freedom to be who you are. Unbind, unwind and walk the path of your unbound soul, come back to love restored, complete and fully whole. Creating and walking a path that only a fearless way finder might take, for these steps are essential and are steps destined by your fate.

About Babita Gill

Babita is a mermaid that sometimes dresses up as a human woman. Hehe. She is a woman for whom writing is as essential as the sea is. It breathes life into her.

Babita is a creative who reunited with her creativity in recent years. She loves creating healing arts and crafts, written words and photography. She is a healer who combines 23 years' experience of supporting with conventional therapy and 10 years of the wisdom of ancient alchemy (this lifetime anyway) to create changes for herself and those she supports.

Babita has worked with men, women and children internationally through one-to-one sessions, initiation journeys, groups and retreats. She has lived in gorgeous Bournemouth for the last 12 years where her soul feels so at home. Babita is blessed with a tribe of people who resource her and who she has the great privilege of holding close to her heart.

Instagram: @babita_gill

LIVING UNBOUND AND BAREFOOT

By Carrie Myers

When I told my husband the prompt for this book was 'What does it mean to walk along an unbound path?' he said, 'Hmm, the story of your life!'

I guess I have always been a bit unbound. As a middle child, I tested the rules and pushed the limits. I was a cheerleader when cheerleaders were not held in high regard. I showed up wearing the red dress when I was told to wear the brown one. So, I guess I have always walked a little left of the 'right' path. Though, unfortunately, not free of all the 'shoulds' and rules that engulf us in our society. The checklist of expectations began young, but in the seventh grade they fell on me, full force! I let these rules begin to accumulate and take me by the hand for close to 40 years, leading me away from myself. That checklist included people pleasing and all the ways of the 'good girl' for many years. I was dull, predictable, scheduled and almost robotic. I was domesticated and bored.

Then the unfurling began.

After a tumultuous chapter in my marriage and within myself, I woke one morning to the determination that I no longer wanted to be who I was appearing to be in the world. I had felt heavy and cloudy for several years and I craved clear skies and lighter steps. No, not just lighter steps – I wanted to dance through my life, picking flowers for my hair, spreading joy and wisdom to all that shared space with me. I wanted to learn, to grow and to FEEL! So, I began sloughing off those

'shoulds' and expectations that kept me chained to my smallness, my list of rules and to all those that felt I should be of service, never returning love to me. I knew I was and am more than a clean house, full pantry, and dinner on the table at six. I asked myself, 'Who am I? Who is this woman in the mirror looking back at me? What do I want? What do I need? Who am I created to be? What impact am I destined to make on this world?' WOW! That one question... *What do I want and need?* Those words lit me up!! It took me some time to sit with that one. I live a blessed life, but my conditioning led me to believe that I should not ask for more than I was abundantly blessed with. But my heart leapt with desire and was ignited on fire when I asked myself this question!

That fire, warming me from the inside out...YES!! Passion! I want to be passionate about my life and my impact on this world. Reading, writing and diving deep into whatever caught my attention, I unfurled and began to creep, like ivy, toward the sun. I felt myself getting warmer, freer, more grounded, yet expanding into the ethers! I ran away to adventures and solitude to feel out of my heart and into my soul. I walked barefoot in the woods and stood with cold water running over my toes and ankles, connecting to the earth, spirit and ultimately, to myself. I danced naked in a cold March rain. Meditations became guidance from deep within and from that above. I felt into me. I felt into the connectedness that is us, as women, as humans. I allowed the letting go, releasing the binds that took up space, then using them as the cables on the bridge that returned me to myself. I listened to my gut, my soul.

And when I listened, I heard it. My authentic self, my soul's purpose speaking to me. She came out of the shadows, brushing off cobwebs and said, 'I thought you would never find me!' I wrapped her in the biggest hug and said, 'I did not even realize you existed until I heard your faint voice from

deep inside myself! And now, NOW, we can sing to the top of our voices and dance until the moon and sun merge, lighting the path we are meant to walk *unbound, unfurled, free and spirited.'*

Me and my unbound self, all intertwined together, walked barefoot, open hearted and soul shining into the world.

I no longer hide behind my stories, creep among the brush, or stay buried in expectations. I tell the truths of my journey to lend hope and strength to others, so that I might inspire change within them to find their unbound path and live from their soul's purpose. So, you ask, what it is like to live walking an unbound path? It is the hardest easy thing you can do. Listen. Listen to the faint voice deep within you, calling to you to invite her into the light. Listen to the moments when you are coming out of your skin. Listen to the messages of sleepless nights and find the clarity in the 'What ifs.' Then light the torch, take off your shoes – maybe even your clothes, but especially your masks – and walk into the forest, following that voice – your voice. Your voice will lead you to the clearing, where the sun is shining on the path you are meant to explore as you begin to unfurl and expand beyond your wildest dreams.

About Carrie Myers

Carrie J. Myers, MSW, RYT 500, wife and mother of three, has been writing since she was 10 years old. Her poetry, which reflects the phases of her life, has helped her process her journey along the way. As a yoga instructor, she discovers new ways to dig deep into her subconscious, pulling from her practice the words that hold higher meaning and growth. She hopes to inspire change in the hearts and souls of her readers, while holding space for each interpretation to resonate with each soul's purpose. Carrie is passionate about creating and recognizing the beauty in the mess that life can throw at us at times. Her goal is to help readers to rediscover their authentic selves and revive, create and excavate their light from within. She is also the author of *Soul Confetti: Celebrating Life's Lessons* and lead author for the collaborative book, *Soul Shine: Excavate Your Light and Claim Your Soul's Purpose.*

For more from Carrie, visit her website: carriemyersauthor.com

Walking the Unbound Path Towards Belonging

By Claudine Nightingill-Rane

I never felt like I fitted in. I never felt like I was included. I was always on the outside. Sometimes literally, the girl gang at school that I so desperately wanted to be a part of, would allow me into the inner sanctum for one moment. Next, they'd deliberately form a circle of loud whispers with me on the exterior, ensuring I could hear snippets of what they were saying about me. Not all of it, just enough to ensure I felt suitably excluded and ostracised; cast adrift. Now, 30 years on, when I see people whispering, I wonder what they're saying about me, or why I wasn't invited to the thing, until I remember I am no longer that child and it doesn't matter, even if I am the subject of their conversation. What other people think of me is none of my business. A hard lesson to learn, and yet so liberating when I did.

Learning to walk the unbound path for me was a magical realisation that I don't have to fit in or be liked by everyone. Back in those school days, I wanted to rebel and rock the boat in order to be accepted by the cool girls. It was about deliberately not conforming, so I'd stand out and wasn't deemed dull and spiritless and thus, excluded.

Now in adulthood, I know that my choices to be unbound are choices for me. I no longer desire to fit in. Well, most of the time. Because we have all had it ingrained into us that we need to conform in some way to society's norms and ideals. The need to be part of a tribe was a survival mechanism back in the day when we had a much better chance of surviving a

sabre-toothed tiger attack in a group (or at least be a faster runner than the one at the back, so they got eaten first). Still now, the societal message is that if we don't follow the tide, go with the flow, we're failing or we will offend others. And goddess forbid that we offend anyone with our own truth and honesty by living life as our authentic selves.

But what if we decided to walk the unbound path, doing no harm to anyone, living in a way that serves us and makes us whole; makes us belong rather than sculpting ourselves and chiselling off bits so that we are liked and included? Brené Brown says that these are opposites. Fitting in involves lots of 'shoulds' and true belonging doesn't require you to change who you are – instead it requires you to be who you really are. What if we dared to take our place in this world – not by being loud or outwardly confident, rather in a way that works for us, as such embracing our introverted nature? What if we take up literal space by being in a body that is bigger than 'they' say it should be? This might not get approval from everyone, yet that is not what we are here for.

If society learned to accept us all just as we are, without social norms telling us how we should or shouldn't be and if, on the other side, we chose not to try and fit ourselves into the mould of being 'more of this' or 'less of that' to be more acceptable to others, and instead we learned to be truly ourselves, we could make such an impact in the world. If we could spend less time preoccupied with whether we are pleasing to 'them', we could get on with what we are actually here for. We often worry we are too much or not enough – but for who?

Belonging would be about finding those accepting and appreciative of us, just as we are, rather than altering, shrinking, dimming ourselves just to align. What if we all lived like that? We might have less friends, followers and likes, but we would be walking the unbound path with those with

whom we belong, in the place where we are fully and wholly embraced.

It's a choice. For my entire adult life, I had a choice which I didn't see until I hit 40. I didn't know that dieting wasn't a compulsory part of life. Striving for an acceptable body shape, clothes size and weight (not even perfection) wasn't a mandatory requirement for being a woman. Not even to be an attractive, healthy and fit woman. A revelation! I was putting my life on hold thinking I'd be happy when (insert as appropriate): I'd lost weight, I'd dropped a dress size, I could run 10k without almost collapsing in a sweaty heap.

Like dieting, many things are a choice; not everything, but many things. A choice to edit parts of ourselves to be more palatable, rather than waiting to find true belonging. A choice to worry about being confident, not overly cocky, and not too shy either. A choice to fight ageing with anti-wrinkle serums, Botox and hair dye, or losing weight and trying to control how our body looks. It is a choice to follow these rules that the patriarchy set and many of us have chosen to follow. It is not a condition of having a valid and deserving place in this world. You already have that, unconditionally. And when I was armed with this knowledge, I was liberated and empowered to make a different choice.

I invite you to get curious, to wonder what your unbound path is and where it will take you. Where are you bound by rules that don't serve you? How much are you living life the way you've been told you should, showing up as the most polished version of yourself for fear of others' judgement? Shrinking yourself or dimming your light to fit in?

What would it mean to remove those shackles? What would authenticity look like for you? What would the unbound path lead you to?

I'm not saying it's an easy road to follow. Sometimes it feels easier to walk the trail dictated by others, to go with the flow, and not rock the boat. But we only get this one brief and precious life.

Will you make the brave choice to follow your unbound path?

About Claudine Nightingill-Rane

Claudine Nightingill-Rane lives in Hove, Sussex, on the south coast of England. When she's not coaching, writing, parenting or wife-ing, she is usually in the sea, on a yoga mat or in her hammock lost in a book.

Claudine spent a good chunk of her life not feeling good enough: her body, her personality, her everything, thus hiding away and editing parts of herself she thought weren't likeable – until she realised that she didn't have to be liked by or attractive to everyone, nor fit society's narrow beauty standards, to be worthy.

Sea swimming has enabled Claudine to flow along this journey; learning that the blocks in her way were in her head and learning to appreciate what her body does for her – and allows her to do – was a game changer.

It enabled Claudine to create a vocation combining her passions: helping girls and women harness the healing power of the ocean and learn to accept themselves as they are – mind, body and soul.

You can find Claudine on the social channels @SeascapeBlue

My Heart's Legacy

By Deborah DLP

I could feel myself moving further away from the here and now. Floating off into a space somewhere in the distance. The white light swirling ahead of me as I sensed I was slipping away.

I cried out, 'Am I dying?'

I then heard a faint whisper of a voice reply.

Coming to, in the recovery room, I knew something profound had just occurred during my heart surgery.

I was still here. A second chance at life at 55. This was *a turning point.*

During my initial recovery, something bigger and deeper was being revealed.

I turned to my journal. I began capturing everything I desired from my life going forwards now. I was moving beyond midlife, towards the decade of 60. A stark reminder that I had lived more years and decades than those left. I was questioning and seeking answers. How had I ended up walking a variety of different paths, some of my choosing and others that were certainly not?

It takes courage to sit with yourself, doesn't it? To cast your mind's eye back and notice the choices you made. What you might perceive to be the mistakes and wrong turns. The unexpected and unplanned decisions, and the journey you find yourself on, asking yourself, 'How the heck did I get here?'

It was no surprise that I found myself reflecting over the decades and seasons of my life.

It was glaringly obvious to me as I journalled that leaving school at 16, I had been seeking a path where I could be myself. I wasn't willing to walk the same path of two generations of women before me. I didn't want to be the third woman in my ancestral line to be married and a mother at the young age of 19.

No, no, no.

I wanted something different. A path filled with variety, travel, freedom, excitement and adventures. A path where I was true to me. After a few years of exploring, I finally found myself embracing my first unbound path, the one of my choosing. I felt excited for my future. I was delighted by the choices I was working towards and the lifestyle I was creating.

Can some things be too good to last?

During my midlife my world unexpectedly turned upside down. The unbound path I had worked so hard for, and finally settled into, was now crumbling away underfoot. I found myself facing life-changing events outside and beyond my control.

It took all my strength and courage to decide to walk away from my path and my beloved career. I found myself in a liminal space. I felt lost, adrift and stripped of my identity. I had no clue what was next for me.

Have you ever felt lost and adrift, without direction?

I didn't know who I was anymore.

The only thing I knew for certain were the arms of loss and grief continuing to hold me tightly.

Little did I know that having heart surgery at 55 would see me come full circle in exploring and finding my next unbound path. Life often works in mysterious ways at times, doesn't it? If you are curious about what the little whisper of a voice had to say to me during my surgery, it was this: my life was unfinished.

I knew that this was an *invitation from my heart.*
It was time for me to honour the second chance I had been given. I was ready for something different. I knew deep within that it was time to create a way forward and *find a path uniquely my own.*

Albeit I did not know what that path looked or felt like yet, but my curiosity was piqued. I went deeper into self-inquiry, asking the proverbial question: *what's next?* Ruminating and hoping for clarity to strike. How many times have we asked this question of ourselves over the years?

It takes time to untangle the threads, to discover what you seek and yearn for. Particularly when you have always put others first. I wonder how many of us have experienced this?

Gradually, more and more signs and synchronicities appeared. My creative passions were taking on a new form and shape. Different values were emerging. I saw options and choices being revealed, aligning with my heart's desires.

My curiosity had been ignited. There were unfinished dreams and adventures waiting for me.

A path was hovering in my awareness as I moved closer to the decade of 60. This next decade felt more significant and important to me than previous ones. My circumstances and

lifestyle were now different.

It was *my time* now, to choose my own direction, boundaries, terms and conditions. Knowing that I could add, revoke, alter, adjust all or any of these.

I made a promise to show up for myself. To be true to myself. No more waiting or dilly dallying. Those days were gone. I could feel the fire and hear the roar in my belly when uttering these words. When you know, you know, don't you?

Owning this whole approach felt empowering and truly unbound. I wanted more of that – who wouldn't?

My unbound path was once again in plain sight and within my reach.

- ♥ I knew it was time to put down what I had been carrying.

- ♥ Reclaim the lost and forgotten pieces of me.

- ♥ Connect with the wise woman residing within.

- ♥ Trust my creativity in expressing myself, in my unique way.

- ♥ Honour my beautiful and ageing body, embracing all that is changing.

My Arrival

I am living proof that life can change in a heartbeat. In listening to and following my heart, I know I am not too old and it's not too late to begin again.

I have finally found **my unbound path** again. This is exactly where I am meant to be. I am here creating my own unique **living legacy.**

There You Are...
And now she rises.

About Deborah DLP

Deborah is a gentle creative guide, writer, avid photographer and beautifully unfinished woman.

She has found herself being a witness and a guide to many women at pivotal turning points and when they are facing transitions in their lives; she knows the challenges of invisibility, feeling lost, adrift, and of life being an unfinished journey.

Deborah believes that nature and creativity are portals to connect with ourselves. It was nature, writing and photography which offered Deborah her own sacred medicine, seeing herself reflected through the lens of her camera, her heart, nature and the seasons of her life.

Deborah will gently guide you through a series of creative invitations infused with nature, photography, writing and the lens of your heart to help you see yourself once more. Inspiring you in reclaiming and reawakening the forgotten aspects of who you yearn and seek to become in this season of your life.

You can follow Deborah's journey on Instagram:
@beautifullyunfinishedwoman

HARMONIZE WITH YOUR INNER TRUTH

By Diana Morgan

There is a feeling deep within, of complete trust and knowingness.

Has it been pushed down, or told to be quiet?
Have you ignored it, only to upset yourself later?
Do you hear its whispers, however hushed?

In this place, only *you* exist.
There is no doubt or confusion.
You do not need to ask anyone
for permission, or to hold your hand.
You have walked boldly
through the fire
many times before.
Do you remember?

'Be yourself,' they say.
But have they had to spend 40 years
discovering what that even means?
Do they truly know the struggle
of being a skillful chameleon?
Have they experienced the lows
of staying hidden out of paralyzing fear?
Has the world felt safe to them?

'That's not who you are,' they say.
But how do they know,
when they do not even know themselves?

Do they spend hours, days, weeks, years...
learning the inner workings of their own minds?
Can they say with certainty their evolution
has reached its peak?
Would they receive this judgment themselves?
'Get a job,' they say.
But do they know how to harness energy
and create something out of nothing?
Do they see the owl,
and feel what it's like to know all, and fly?
Can they hear the bountiful messages
of the ancient forest?
Would they even listen?

'Do it this way,' they say.
But have they ever tried
doing it another way?
Do they enjoy repetition
and robotic behavior?
How boring are they?

'Listen to this person,' they say.
But do they know how it feels
to be inside the lens of *this* person?
These cells, this soul?

'Follow the plan,' they say.
But do they even like it?

'It's all in your head,' they say.
Yes, and so is everything,
before it becomes
luscious reality.
It is not our role
to pacify their misperceptions.

Their eyes glaze over
when you share your dreams,
the inner workings of your mind
and heart.
The door to their third eye remains closed.
It is not for you to open.

The drumming of your heart pulses on…
Nourish yourself.
Drink from your own spring
of life.
Oh, the wonders you hold!
Embrace and envision
your *most nourished* self.
What are they like?
What is their preferred nourishment
for mind, body, spirit?
What makes their heart feel
at home

Collide your visions,
hopes and plans.
They are one, not separate.
They make up ALL of you.

Honor each step.
Gold appears beneath your feet,
once you move forward with
unwavering intention.

You know who you are.
You know why you are here.
All doubt is merely illusion.
You are not beholden
to time,
to people,

to places.

You go where you are needed.
You follow when you are being led.
You trust yourself.
When all is quiet,
YOU TRUST YOURSELF.

And that is all you need.

Distract. Disrupt.
This world design.
But YOU.
You see through it all.
You bide your time.
You observe.
You know a lot more
than you ever let on…
It hasn't felt safe.
So you've kept yourself hidden.
—The ultimate secret—
to not share the inner wonders
of your brilliant mind…
out of fear of what may happen
if you were to peek out and share.

I see you.
I am you.
And now is our time
to show up for ourselves.
We are here.

The world may not feel ready
to embrace all of who we are.
We are the awakening.
We are unraveling damaging patterns.

We are rewiring the grid of humanity.
We are the pulse
of the human condition.
We are who we are.
And we are not going anywhere.

We are warriors of the new world.
Our voices matter.
Our words matter.
Let us join together,
in a co-creational matrix
of the highest caliber.
Potent Potions, we are…
Will you heed the call?
We not only move to the beat
of our own drum…
We dance to it!
We not only speak our intentions –
we sing them!
We follow our own ethos.
We don't care what anyone else
may think or say.
We cared for far too long.
And now we RISE!

Embodying
The Goddess
means
peaceful observation
from an all-seeing perspective.
It is leading, by BEING.

It is walking in truth,
sometimes alone.
It is honoring the mountain lion
more than the man.

It is an easeful flow
that cannot be pushed around.

It is a deep rooting into the veins
of our ancestors,
a calling from generations past,
twisting up from the earth
and into our blood.

It is Gaia speaking,
directly to the soul,
naked and sovereign.

Keep your heart open;
turn away from adversity.
Hold yourself in love.
'I love me and that is enough.'

Safety within yourself
is the seed
of creation.

Remember who you are.
Remember who you are.
Remember who you are.

Spirit draws the lines.
It's up to you
to create the art.

About Diana Morgan

Diana Morgan is, above all, a voice for Gaia. As an author, singer/songwriter, artist, intuitive healer and visionary, she weaves her life into a dance of devotion to embodying and sharing the wisdom of our wondrous planet. Diana believes in leading a life of truth, integrity and self-responsibility. She is passionate about guiding fellow neurodivergent people into fully owning their creative and intuitive gifts, while being at one with nature. Diana is the female half of the musical duo Aligned Alchemy. She lives and plays on hundreds of magical acres in the Appalachian Mountains of eastern Kentucky with her partner and cats. To learn more about Diana and connect with her, visit https://www.ohyesthis.com.

The Bars We Cannot See

By Helen Llewellyn

So many of us feel like caged birds, watching days ebb and flow with little or no change. We peck, we nest. We chat and we strain to see the light, but to little avail. There is never an opportunity to spread our wings, to soar, to revel in effortless flight over the undulating countryside below us.

The truth is that we built the cage around ourselves. We were encouraged to work, to have, to achieve, to provide. Before we knew it there was no time or space to fly or explore, we had to work harder, have more – and so the cage is reinforced. I have a secret to share…Don't tell anyone beyond your closest, dearest friends and family or everyone will do it.

The secret is that we are beings of energy so we can escape any time we want to. We just have to trust ourselves, tune in and follow the energy.

I know that it may seem scary, outside the cage of rules to rely on, but you will fly if you choose to give it a go. Just like swallow chicks who push off, within a fortnight they might be in Morocco.

So, 'What's this about energy?' I hear you ask. It's both ancient and modern wisdom, a kind of alchemy of how to turn the fear, the struggle and those feelings of being blown in the wind from one place to the next, never pausing for breath, to one of a golden blissful calm. Sound good? Oh, it is. I dared. I jumped and I can assure you that the view and the feeling of freedom and peace up here is just magical, possibly even more than you can imagine.

Tuning into and understanding our own energies and how they communicate with us the first stage.

Secondly, we learn how other people's energy interacts with us and how we can create more harmony without being a doormat.

Thirdly, we learn about the world's energies and their impact on our lives
Mastering all three layers of energetic connection strengthens our wings, feather by feather. Before you know it, you will be zooming from tree to tree and then soaring on thermals high above. As you learn, others will be braver and will follow you. By taking your first steps you help others do the same and together we create a better, freer, more unbound world full of shimmering energetic birds.

Are you ready to step out of your cage and try out your energetic wings? I will be here right by your side, showing you all I know. There is no risk, the cage will take you back any time. Is it time to change, to be, to become your whole energetic self and find out who you become?

There is no time to waste – jump, jump now. I will catch you and we will soar together until you get the hang of it by yourself. I have so much to share…

About Helen Llewellyn

Helen Llewellyn was born and raised on a farm before she moved away to bigger towns for work and for love. Soon realising that she felt differently and more than most other people, Helen then began a quest: to understand human nature and how we are part of the natural world we live in, inextricably connected.

Helen is now writing and creating art to bring this to life in order to help people like you feel more complete. To know that you are not broken, you have just forgotten how to feel and to connect.

This piece is part of a larger book. You can find Helen on Facebook to be part of the art and creative journey:
https://www.facebook.com/helen.wetton.71

Awakening to the Unbound

By Emma Unsworth

The unbound path for me has been a journey of awakening. Awakening to who I am. A release of conditioning. A place to stand fully in my power and let the weird and wonderful emerge.

As I started down this path, I didn't know what I was letting myself in for. The many layers of masks that needed to be shed, the old wounds and unhealed parts. I wasn't aware of any of it in the beginning, all I knew was something deep down within me was pulling. Pulling so strongly, I couldn't ignore it.

In the beginning, my life felt like a pinball machine, my problems and I bouncing from one extreme disaster to the next. Trying to do all the right things but falling apart inside. Using all the energy I had to hold it all together, keep going and figure it out. Little did I know I was manifesting the whole thing. Maybe it wasn't for me to hold it all together like I was taught, to keep continuing toxic generational behaviours, to keep bound to what I had known.

Exhausted, alone and feeling completely broken. All I wanted was a sign. Daydreaming like the 90s kid I am, fantasising that there would be a big dance number and it would all work itself out...

Oh baby, baby, how was I supposed to know
That I am out of alignment?

Oh karma, karma, I should learn to let you go
And now you're back this lifetime, yeah

Show me how this needs to be
Tell me, Universe, 'cause I need to know now, oh because

My attachment is killing me (and I)
I must confess I still believe (still believe)
When I'm seeking answers, I lose my mind
Give me a sign…
Hit me, life lesson, one more time

Oh karma, karma
The reason I shallow breathe is you
Boy, my ego got me blinded

Oh, pretty baby
There's nothing that I wouldn't do
Avoidance is the way my soul planned it

Show me what I need to be
Tell me, Universe, 'cause I need to know now, oh because

…And oh boy, did I get a sign. So many signs, they were unavoidable.

The more signs I got, the more confusion grew within me. I thought signs were supposed to make things clear, right? My inner world became even more conflicted, confused and overwhelmed.

Operating from so many different ways of being with no clear overall thinking. Parts of me were holding onto the things I knew, the things that I thought would keep me safe. This only created more dysregulation. Feeling like a walking contradiction, the breakdown was inevitable. The idea of who

I was crumbled. In order for me to step out of the trap, the illusion had to break down...

I'm caught in a trap. I can't get out.
Because I love 'shoulding' myself too much, baby.

Why can't you see, what society is doing to me?
When they don't believe a word I say.

We can't go on together, with bounded minds.
And we can't build our dreams in outdated ways.

So if an old friend I know
Stops by to say hello
Would I see the truth in their lies?

Here we go again
Asking where I'm going
You can't see I'm off to change my life

We can't go on together, with bounded minds
And we can't build our dreams on limited ways

Oh let my mental health survive
Quick dry the tears from my eyes
Let's not let the good things die
When honey, you know all that's happening is lies.

We're caught in a trap, I'm getting out
Because I love myself too much baby
Why can't you see, what narcissists are doing to me?
When you can't believe a word they're saying.

Well don't you know, you're choosing the trap?
You're getting out.
Because you're on the unbound path, baby.

…This is the freedom to be.

This is the gift of the unbound path. Freedom to be yourself. Freedom to choose. True freedom that comes from within.

Within that freedom are so many treasures. Treasures of the inner creative, artist, musician, dancer, writer, healer, mystic, speaker and many more to be uncovered. Once unbound with the space to be, the magic of these treasures can shine through.

Awakening is a journey of becoming. Becoming the light you and the world needs. Allowing yourself and the treasure within you to shine.

The activation of the light within you fires up faded dreams. The dreams of who you were born to be.

As the light within rises, remember…

Let go…if something is actually meant for you, it will stay.

Rest is one of the greatest medicines.

Everything you need is in this moment – are you allowing yourself to access it?

About Emma Unsworth

Emma is a life coach, creative, entrepreneur and intuitive guide.

Her role in the world is to inspire and empower people to live greatly. To help them expand and be who they were born to be, doing this through energy work, meditation, psychic channelling, mindset coaching and facilitation.

The founder of Source Oneness, a transformational coaching company for life and business, Emma is currently on a mission to empower conscious leaders to shine their light in the world.

www.emmaunsworth.com

A Ripple of Change

By Simone Grove

Walking an unbound path for me means hope, it means changing lives, it means creating a ripple of change. A ripple of change and a new way of thinking, or perhaps returning to an old way of thinking? Whichever way it is, unbound is about transformation and change. It is about remembering who we are within and the incredible magic and power each and every one of us holds.

My unbound path is far from conventional and I love thinking of this journey as unbound. Unbinding from the conventional truths of life as we know of it – in particular, healthcare as we know it. Empowering people to trust their inner power, their inner wisdom, their inner energy, the core of their very being. My unbound path is a calling for people to remember who they are and to look within. So often we seek support and guidance from outside, and the answer always lies within.

My unbound path is in the world of cancer care. A world that I see in duality. A duality of right and wrong, black and white, fear and faith, doubt and trust, conventional and alternative, traditional and integrative, one way or another. A world I see through my own eyes as a specialist oncology health professional and as a holistic integrative practitioner.

Walking an unbound path for me means speaking my truth, trusting my intuition, trusting the magic that I see each and every day with my own eyes. Turning on a lightbulb for humanity, opening up an awareness for all to see that what we believe to be our truths may actually be the things that are keeping us stuck. It's time to remember the power that

lives within us. We are conditioned to fear the word 'cancer,' and yet it is simply a word. Fear keeps us stuck! And yet we continue to condition for illness and fear, rather than wellness.

Walking my unbound path means flipping a switch. Remembering who we are, the powerful energetic beings that we are. The power of our mind-body connection is so magical, and so forgotten. It's time to remember that there is always a choice. A choice in everything we do, in every thought we think, in every emotion we choose to hold onto or release. A choice in the way we use our energy, the magic within. A choice in how we allow our emotions to have an impact on our physical and emotional wellbeing. A choice in the words we speak, a choice in how life gets to be.

Walking my unbound path is placing the stepping stones across a turbulent river; a connection, bridging the gap between conventional and integrative. Understanding that everyone thinks differently, that everyone has their own model of the world. Giving permission to listen, to recognise that people may not all see eye to eye, and that is okay. I desire to model to healthcare professionals, especially those working in cancer care, that a patient may think differently to you, and that is okay. And that as a healthcare professional is it okay to think outside the box, to look at alternatives, to listen to what people are saying, to feel their feelings. I desire to model to others that we are all individuals and that one treatment doesn't suit all. And most of all, my unbound path is about shining a light on the alternative avenues of hope.

Each and every one of us came to Earth with a soul purpose, and for whatever reason cancer enters the mix, whilst it may not seem like it right now, there is always a reason, a bigger purpose. Life lessons are valuable, and yet so often we fear them. We put our entire faith and trust into other people's hands to heal us, don't we? How often do we go within to find the answers?

Healing starts from within, following your soul path, trusting the process, trusting your intuitions, trusting the power of your mind-body connection. I believe this is the key to our health and wellness and this is my unbound path.

I am walking this unbound path to empower as many people as possible to regain their inner power. To embrace the magic within, to trust in what feels right. The ability to trust our inner knowing, to listen to the messages our body is telling us. It's not about one way or another way, it's not black or white, it's not about right or wrong. It's about tuning into your mind, your body, your inner knowing. It's about making your choice that feels best for you because each and every one of us sees, hears and feels our world in our own unique way. This is our magic; it's time to remember the power that lies within.

Simone x

About Simone Grove

Simone Grove is a specialist physiotherapist in oncology and palliative care, holistic therapist, energy alchemist, intuitive coach and Master Practitioner and Trainer of Neuro-Linguistic Programming. Her entire ethos is focused on embracing wellness rather than illness. Simone empowers everyone who enters her world to live the best life possible during and after cancer treatment, by harnessing the power of the mind-body connection and an understanding of energetics. Her expertise is unique with an equal blend of specialist clinical oncology knowledge and expert holistic healthcare.

Energy and energetics are Simone's passions and she truly believes energy plays a key role in health and wellness. Words, thoughts, emotions and energy are more powerful than you may ever imagine. The fusion of clinical, holistic, energetic and spiritual work that Simone does is magical.

www.soulalignedwellness.com

YOUR MEDICINE LIES WITHIN...

By Jo Meadwell

Eeeeee Eeeeoooooooowwwwwoooooo…Arrgggghhhhhh!

My primal scream could be heard throughout the land. Or was it an internal cry from somewhere deep, deep inside that was aching, longing, wanting a release…from what? My body? This journey I am on? Life?

I questioned, 'Why me?' to my ancestors. 'Why didn't you do this work?' Instantly knowing that this was a foolish statement and yet in that moment it needed expressing, to be heard, seen, acknowledged and witnessed.

A voice from 'somewhere' responded with a quiet authority: 'Darling – YOU are your ancestors; your soul chose this time to be alive on Earth to embark upon this mystical magical journey of clearing the patterns, healing the lineages and opening the way for a new life on Earth – how exciting is this? Ancient wisdoms being returned, wounds being healed and a transmutation of all that doesn't serve.'

I recall the re-remembering of who I truly was in my mid-thirties. I don't think there is a set age, we all take a different journey. For me, following a nudge to move to the Middle East to set up a coach training business (which took a whole heap of courage, trust and faith) put me in a place and a space away from that which I was familiar with – a new country, new territory and a feeling my soul knew these lands oh so very well.

The medicine our souls, bodies and minds need lies within us all, our lineages and a connection to our ancestors, our roots of existence. Taking an inner journey is not for the faint hearted and yet as we travel this path exploring the mystery, the true magic and joy that is discovered amongst the messy, often rocky path will lead you to your truth, your essence and ultimately a liberation that invites a powerful presence within…

Your soul will nudge, call you and ultimately scream at you to take this journey if it's for you. Often, we resist; it feels hard, unknown and uncertain, yet there comes a point when we can either no longer resist or we consciously choose to cross the threshold and enter a whole new world of awakening, exploration and mystery.

Is your soul calling you to take this journey inwards?

About Jo Meadwell

Jo has a unique talent for facilitating lasting change and deep transformation in restless leaders, who know there is a better way and want to access that something more within.

An engaging keynote speaker, executive leadership coach and author, Jo has over 30 years' experience coaching international business leaders and teams to achieve greater success. She empowers leaders to transform themselves through inviting a deeper connection to their souls, listening to their intuition and honouring their core values.

Jo's combination of ancient wisdom, intuitive questions and no-nonsense approach invites a pathway to a deeper inner journey and an ultimate liberation to a more fulfilling life, purpose and way of leading yourself and your teams.

To connect with Jo, please visit www.jomeadwell.com

A Beacon of Light in My Storm

By Lindsey Elms

I sat in my car as the wind shook me. I could hear the sound of trees falling and the rain battering my windscreen. It was pitch black and bitterly cold. Inside my car I was shivering, my body reeling from the news, trying to shake it off like a bad dream. I thumped the steering wheel, wailing, sobbing and despairing.

What was I going to do? How could this be happening?

It was the worst storm we'd had in a decade, the evening of my 20th wedding anniversary and my husband, out of the blue, had told me he was leaving.

A wave of shock and panic rippled through me. My stomach felt like it was inside a washing machine's spin cycle and as the waves of emotion grew stronger my heart pounded faster and faster, almost beating out of my chest.

The events outside so obviously reflecting my insides.

The man who I thought was my soulmate, who I would grow old and wrinkly with, had decided to leave me, our kids and our home and move to the other end of the country.

Of course, like every marriage we had our share of challenges, none though that I thought were insurmountable. Sometimes I forgot to do the washing up, sometimes he forgot to get a card. We had grown up together and became better people

because of our partnership. Every day there was a check in call from him and I'd get a schoolgirl sense of excitement when his car pulled onto the drive.

This was the man I was so connected to that we simultaneously chose the same Christmas lights at different shops on the same evening. I got a better deal!

And yet there he was, shoving a few items of clothes into a bag, me following him around the house like a lost sheep trying to get him to talk to me, to make sense of what was going on. Him looking up at me with a teary blank face saying, 'I've made my choice; I just have to go.'

I felt my whole world crumble down.

I had wanted so badly to prove to my kids that love can endure, to spare them the heartache of parents separating. I felt I had failed them and my future grandchildren.

For the last few years, I had tried to fix the subtle grumblings of his discontent, whilst at the same time coming to recognise mine. I felt that love conquers all, believed that marriage is worth fighting for. With both of us experiencing the loss and disempowerment of our parents divorcing, I hung on with all my might for our children not to have the same fate.

At first the pain and grief of this earthquake ripping through my life was unbearable.

Life was presenting me with a choice – to stay bound and stuck in anger and disappointment or I could pick myself up, dust myself off and choose love.

Up to this point, my beliefs and expectations were wound up in fairy tales and service. Choosing love meant unbinding

myself from old expectations of who I was and how I show up in the world.

Choosing love was an invitation to live a truly soul-led life grounded in self-belief. Amidst the pain and grief of separation it was my lighthouse. A beacon of light, rising up out of the darkness. A tall, stable, safe harbour to focus my gaze and tumultuous emotions.

Walking down this new, unexplored path guided by love was a process. Although I did not know where the path would ultimately take me, it felt right. I felt completely supported and safe. Every turn has offered me a friendly ear, a warm hug of encouragement and lucky synchronicities that have propelled me forwards and held my resolve and focus not to look back.

Each step invited layers of me to be released. It was like I'd been wrapped up for years under many layers and as I walked, I discarded an item at a time, leaving a trail behind me. Each item discarded leaving me feeling lighter, freer and more peaceful. Ultimately, I am comfortable in my own skin, accepting of my true nature, freckles and all. I know in my bones that I am lovable and that I have a beautiful love to give and share.

The layers had kept me warm and cosy all these years, or so I'd thought. In fact, the warm fluffy scarf of not speaking up for my needs and wants had been strangling me. The heavy, waterproof coat had protected me from accessing my true feelings instead of allowing my tears to flow easily over Teflon. And the belt around my waist was a tourniquet for keeping 'everything together' even though it pinched.

Now I walk with a spring in my step, with my head held high. I feel light and flowy like a summer dress blowing in the gentle

breeze, unencumbered by expectations and allowing my creativity full freedom of expression.

When the waves of emotion rise, I simply notice them, observe them and let them take their natural course. Sometimes they crash to the shore, other times they gently ripple, tickling the sand. I am nurturing, compassionate and kind towards myself. I feel a wonderful sense of calm, with a constant subtle hum of loving support that is inside and outside of me all at once.

About Lindsey Elms

Lindsey Elms is a love and connection coach. She lives in beautiful Northumberland with her family including two Patterdale terriers. Lindsey, a great listener with a kind, open heart and an intuition for potential, gently inspires women to connect with their own inner peace, self-love and balance, especially during times of unexpected change, loss and grief.

With her writing, coaching and healing gifts she leads women through a transformative experience, aligning them to their natural power and strengths, weaving a path to empowerment, clarity and self-compassion.

Lindsey consults the ancient wisdom of Nine Star Ki, a foundational tool in her work with women. She has studied this insightful cosmology for over a decade and has been mentored by world-renowned teachers in this art. Utilising her toolbox of alchemy and natural wisdom, Lindsey is a container for change, skilled at creating a safe space for self-discovery and healing.

https://www.facebook.com/likeLindseyElms

Meeting My Book Muse

By Magdalena Samulak

There is a book floating within me. It is a secret message between my soul and my brain and it stays there, because I am a good secret keeper. Now it starts to feel like the sea, it spreads more words with every wave…There is no stop to the waves, they will overflow and drown me – I must allow it, let it all go out; I need to open the mystery door!

I took a walk with a thought of talking to my book like it is my dear friend. I stepped on the unbound path and there she was – my Book Muse, smiling, waving at me. First, I saw a bit of a reserved young lady. I asked her a question: 'What should I share?'

She answered with a question: 'Do you know how you do it, always being positive, optimistic, hopeful?'

I was surprised, but I remembered people sometimes asking me exactly the same thing. I guess that seems to be good idea to write about. I have developed that attitude through several ingredients – like my grandma's beliefs, my inner child, the concept of maybe, going crazy sometimes…that is just the beginning.

While talking to my muse, I realised she is always waiting for me by this amazing tree. She chose a good, huge oak tree that gives nice shelter – just in case some rain catches me on my way there. She pulls me into writing every day now, like a powerful magnet. We walk together, find a bench to sit down and we tell stories, we exchange ideas.

Last night I met her in a dream, in a different place this time – on a beach that's as white as flour and shining in the sun like glitter, my favourite place in Cyprus. We sat ourselves on the sand and we just observed and listened to the waves, relaxing…She helped me to discover more, to dig deeper, to keep going, keep flowing, even against or with my fears. She was different today – a little girl, maybe six or seven years old, cuddling up to me.

The sun was setting, I was tired, so I told her I will be back tomorrow. My muse stuck out her little finger, asking, 'Pinky Promise?'

I answered, 'Yes, because that is the most powerful promise.'

About Magdalena Samulak

Magdalena Samulak is an experienced teaching assistant who works with children with special needs. She lives in Shrewsbury with her teenage daughter, partner and a cat. She came to the UK from Poland about 15 years ago. She started her immigrant life by studying in Denmark for six months. After her studies she travelled to Cyprus, where she lived and worked for two years.

Magdalena loves animals, fantasy books and creative ideas for children. Her inspirations are people, human interactions, imagination and magic. Recently she began working towards publishing her first book and also writes a blog called *Considerations of Lady M* (Magdalena S Writes).

https://www.facebook.com/profile.php?id=100069669311359

EL KHALIG

By Rachel Haywood

When I think of walking an unbound path, I get visions of gold and beige, the great unravelling of a bound mummy, revealing a naked goddess in the shadow of distant pyramids, on a sandy North African beach. Great cascades of almond coloured linen, billowing as demonstratively as Dido's funeral pyre, sending a bold message out to sea.

The freedom, the stripping, the unbinding. Shedding those layers of conditioning, expectation, culture and society. The privilege. The latter is not lost on me, but the more of us who step onto this path, the more momentum, the more permission, the more ease to create a movement beyond sand dunes and start to call in the energy of desert proportions.

But how do you walk away from everything you've come to know, been taught or had imposed upon you?

Slowly. One step at a time.

Becoming unbound takes more than a season. I know that only too well. Despite the beckoning freedom, it's not always the path of least resistance. It needs a strong intention to start, followed by a solid commitment. Then put a stake in the sand (you'll need it to look back and see how far you've come) and take a good look around. Ask yourself, 'What in my current life needs to change for me to walk an unbound path?'

The breakdown of my marriage was the starting point for me, and when I could finally see past the tears in my eyes

and what felt like the wreckage of our lives, I had the most incredible sense of liberation. And while I know that not everyone's marriages feel like that, mine did, and it was an overwhelming invitation to never let anything restrict me in that way again.

I'm relatively new to the unbound path, but it's one that feels familiar to me. My intention is strong and commitment unwavering. It helps to start with a vision: what would being unbound look like? Feel like? How would you know when you're there? For this I had to remember to look within. What did I truly value? It's so easy to lose sight of these things as we move through our lives full of doing and striving for all the things outside ourselves.

Once you've located north on your map, it's time to start walking. Using your body as a compass, feeling deeply into how your experience aligns to that direction, letting freedom, playfulness, exploration and joy be your guides. Allowing your life to feel exactly like that, instead of 'saving them for best'. And always schedule rest stops – there is never any hurry.

For me it was time and space. Which when I look back, has always been the case, but was often met with disapproval. I got the distinct impression it's a very indulgent way to behave. It turns out that unbinding yourself from a husband frees up all sorts of wonderful time for uncompromising self-pursuits – bliss. But creating that within the confines of expectation around working patterns and how I choose to spend my time in general, that's been trickier. I personally feel a day spent in bed reading with cats is rather delicious. I want to be able to watch the seasons change, slowing to gaze at the deep red of the hawthorn berries. I don't want to work within set timeframes. I just don't.

Oh, there she goes again. Back to her teenage rebellion. Which I might point out had few good reasons for most of the constraints. My maiden stropping and sulking about the ridiculousness of the framework, with no-one other than crazy aunts stepping outside the lines. My friend was telling her daughter the other day how much time I liked to spend in my red dressing gown when were younger. This probably spanned school and university until the 'real world' demanded commitment. I managed the transition from unbound to the working bound surprisingly well, thank goodness – then there were the travelling years which were beautifully free.

But once maiden gives way to mother, everywhere you look there is an enormous cloak of expectation, a snake in disguise, ready to coil its way around you and slowly start to squeeze. Like a corset on release, when I was free of my marriage, I was also able to start the lengthy process of unhooking all of the eyelets.

Right as I'm stepping forth into the final phase of my Triple Goddess. Possibly the easiest time to do it, because if you haven't already unbound, nature gives you a helping hand by unbinding all your beliefs about yourself and unravelling your sanity on the way. Unleashing a new vibrancy and power all of its own. Which can be an exciting adventure, as shadow mother is such an uptight place to be. Awash with martyrdom, I'm sure I was constantly frowning, defensive and spiky. Like the maiden before her, stropping and sulking.

I welcome the wise and joyful grin of the crone. I now get to be the crazy aunt. To own and embody it. To give a glimmer of hope to those younger generations as they make their choices in the world. That yes, we do get to enjoy our lives. I'm more unapologetic. I'm also gentler about it – likely to disentangle with a smile than indignance.

So what does it mean to walk an unbound path? Honouring

the truest essence of yourself. Every day. Not when all the work has been done. Not when everyone's needs have been met. But as the highest intention for each day.

It's looking out of your kitchen window across the fields in the late afternoon. Noticing how the clouds are moving through the horizon and the multiple layers are picking out different hues of the setting sun. Watching your cat slink through the grass, then arriving, smelling deeply earthy and damp, as only a cat in November does. Celebrating this space, this time, this writing, as a result of choosing this path.

About Rachel Haywood

With over 20 years' experience in change and transformation in a project management capacity, Rachel found herself on her own personal change curve that required some course correction. This included training as a Wayfinding Coach, Rewilding Facilitator and Breathwork Healer to help others chart a course through change and find their most authentic selves on the other side. She is currently writing her story of change with book, *Gardening with Glass (And The Magical Art of Perseverance)*, which details how the shards of glass in the garden of her 1830s home and former pub are a metaphor for the challenges we find in our lives and how they reflect back our true selves and opportunities for growth. She also runs a support group, Recalibrate, for mums with children with additional needs.

UNBOUND

by Susi McWilliam

Unbound, unbound. This is all I have been seeking. Seeking that freedom, that inner knowing of finding my way. Finding a path and not caring or worrying but being led by my divine self and intuition.

Yet why do I feel stuck? I am wrapped in swathes of ivy. Tangling and tightening around me. The more I wrestle and control and fight the tighter they bind.

Every day I am guided to surrender. To move at the pace of nature, to connect with nature. To give up the ego and force.

So I gave up all I knew, my purpose, passion, business and dreams. I asked the universe to catch and guide me. Yet there is something I am missing.

I have never felt as bound. The universe took my balance, affected me physically. Popped me in a box that I felt was shrinking. I was being crushed. I fought, I cried, I tried positivity, acceptance and more. Yet nothing. The box got smaller and smaller until I didn't care if I died.

Why would I live without purpose, dreams and health? For that isn't living, that is existing.

Unbound, unbound.

In this dark box, I recoiled. I grabbed a blanket and wept. I wept, then wept some more. I began to hug myself, to rock myself and ask myself what I needed. The answer came. 'Be

gentle, rest sweet one, there is something more, I promise.' I grabbed a mirror and looked into my eyes; I saw my soul full of sadness and pain, yet beyond that I saw a powerful leader, a lover, a teacher. There were cracks appearing, light entering. I saw nature in those eyes, a softness. Your softness is your power. Then I heard the magic words, 'I love you.'
'I love you.'

As the tears streamed the ivy that bound me began to release; the box began to expand. Not fully, but enough. Enough to breathe deeply. Enough for a glimmer of faith to weave in on my breath.

Unbound, unbound.

From the space of darkness, the depths of pain and sadness, came the light. The light of love. The light of faith. Not bright like the sun, but like a star behind a cloud, every so often glistening, winking and letting you know all is possible.

I love you, I love you. I love every part of you. Your wholeness, your sorrow, your joy and aliveness. For you are alive. I stroke my skin like the wind caressing my face, I breathe deeply and smile.

You may have felt lost, loss and death, but this was the unfolding, unfurling and undoing.

The path to becoming unbound isn't pretty like opening a gift. It involves shedding, moving, wriggling free from the skin and life that once bound you. As you release the old burdens and ways you become more free, more powerful.

Living an unbound life requires surrender, trust and faith. It cannot be imagined, thought of, or realised until you are there. The path may not take you where you thought, you

may not feel how you thought you would feel.

But you are truly living, alive and free.

Unbound, unbound, forever now unbound.

About Susi McWilliam

Susi is an international meditation and mindfulness teacher, podcaster, creative, community creator, coach, bestselling author, healer and guide. She is the creator of Be Free, a global movement supporting freedom from anxiety. Susi is passionate about supporting women live a life free from the struggles of anxiety, stress and low mood. She is a lover of all things spirituality, healing and natural living.

Susi believes living a life free from anxiety and depression is possible for us all. We can live a life that we love that feels joyful and aligned.

When Susi isn't writing she can be found in nature, or with her horses on her farm in the north east of Scotland.

Website: www.befreewithsusimcwilliam.com

How I Drifted Into the Spiritual Closet and Out Again

By Terri Hofstetter

It was a muggy Georgia day in late April, perfect for a BBQ. Everyone sat outside with a beer, and I slowly got to know my husband's Army buddies and their wives. This wouldn't be so bad. I still hadn't identified as an 'Army Wife', but I could play along. If the others were more like Diane, it would be fine. The guys attempted to fire up the grill and as the women wandered into the kitchen, I followed – but this vegetarian chick wasn't going to play with big hunks of red meat while the girls made mooing sounds as they rubbed spices into it

Dock frowned. 'Why aren't you joining them?'

Wasn't it obvious? Apparently, he had converted to his soldier role well.

I was saved later when the meat started sizzling on the grill. Diane called out to me, 'Terri, did you bring your cards? I'm itching for a reading.'

Yay. Apparently, she didn't fit in with those gals either. We dipped into the bedroom as I spread out the cards on the bed.

After the food was all put away, chilling out, Dock nodded toward Jesse, who was looking all bummed on the recliner. 'He's in a bad mood about his uncle. How about you do a

reading for him? Maybe you can help.'

I preferred pouring a third Bacardi and Coke, but, oh well. It's my calling.

Jesse was keen on a reading and magic started to happen. I was tuning in to his uncle's energy and had almost quoted what his uncle said last week. Jesse was cheering up and relaxing into hope.

Just then, Dock burst in. 'What they fuck are you doing?' He pulled me aside. 'I didn't want you to really do a reading. I wanted you to create 'Happy Land' for him.'

I dropped as the wind blew out of my sails. Didn't he understand?

He didn't know the first thing about owning my craft. I can't ignore my gifts and use them to make some shit up. This would be sacrilege, or a denial of power.

I had just discovered that the man I chose to marry didn't support my highest call. I was moved down a notch right after I had reached the top discovery of my life's calling.

I soon learned I would gradually go into hiding; these steps would lead me into the spiritual closet over the next 15-20 years. I would read cards for only those who I felt safe with. I had already put my peace sign earrings in the ring box and saved them for weekends. Yes, I was to become a weekend hippie.

I would soon alter my wardrobe to fit in during my day job, though it would gradually nip off the buds of my soul's bloom to eventually hide me from myself. It would happen so slowly that I wouldn't discover it until 25 years later. Until then, I would

listen to my boss's advice to dress more professionally and believe I needed it to climb the corporate ladder.

After bailing out of my career 20 years later, and four years as a life coach, I chatted with a medium friend about going back to my intuitive work and merging it into my coaching practice. I explained how I protected myself by keeping my spiritual self hidden at work.

She looked me in the eye lovingly. 'My dear, you were not protecting your soul. You were dimming your light. You cannot live a double life. You have to be true to yourself.'

I suddenly remembered the story about my ex-husband and his friend Jesse.

I amped up my daily sacred practice. Within a year, my title would be changed from Life Coach to Intuitive Soul Guide. I would spend a few years in breath work practice and shamanic and ancestral work, discovering my gifts.

While writing my book, I began to unearth more of my hidden gifts, recalling some in dreams and watching my gifts appear. I'm remembering who I am – who I chose to be when I came here.

About Terri Hofstetter

Terri Hofstetter, an intuitive soul guide, helps light workers and creatives to find their way on their soul's path to purpose.

A Texas native, she began her spiritual journey in her teens, learning at a metaphysical center where she developed her intuitive gifts. She read tarot cards at psychic fairs – quite bold in the Bible Belt.

Relocating to Germany in her late twenties, she worked for the US Government, where she kept her spiritual work to her private life.

After bailing from her career in her late forties, feeling the call to support people in their life journeys, she worked as a life coach for five years before taking the plunge to go back to her roots to soul work.

Terri and her husband maintain a spacious garden in Northern Bavaria with their cat, wild hedgehogs and numerous wild birds. They enjoy hiking in the Alps and the Greek Islands.

Instagram - https://www.instagram.com/terrihofstetter1/

FACING THE FROZEN ONE

By Ríonach Aiken

I sat at my laptop, my mind utterly blank. Aargh. It was like walking through toffee.

I knew what I wanted to say. So why did the words feel stuck in my throat? Why was there a fist-sized knot in my belly?

The temptation to distract was compelling. Check Facebook. Fold the laundry. Put the dishes away. What about that drawer that needs decluttering? Now might be a good time.

Hmm.

I was knee-deep in designing a workshop to heal the wounds of silencing and persecution that have been passed down through generations.

Witch hunts. Suppression of women. Slavery. Destruction of indigenous cultures.

The old traumas that create The Frozen One – the fear of speaking up experienced by women, intuitives, healers, creatives and transformation leaders.

As I prepared to speak publicly about this for the first time, the treacle tension I'm in got thicker and stickier by the minute.

Coincidence? Possibly not.

The Frozen One shows up in many ways.

The Frozen One

I am the Frozen One.
I live inside you.
And I am older than you are.
I am the soul cry of your ancestors.
I carry what could not be borne.

I am the burning of the witches.
I am the blood of the natives.
I am the scars of the enslaved.
I am the wounds of the wisdom-keepers.
I am the silent scream of women.

I have been reviled and rejected.
I have been muzzled and muted.
I have been betrayed and broken.
I have been torn and tortured.
I have been exiled and executed.

I am the Frozen One.
Deny me and you remain frozen yourself.
Silence me and you stifle your own true voice.
Ignore me and distractions fill your days.
Abandon me and you will never feel truly safe.

Can you touch my untouchable parts?
Can you bear loving witness to my pain?
Can you hold my trembling hand?
Can you cry the dark well of my tears?
Can you face the depth of my rage?

I am the Frozen One.
Do not fear me. I am your guide,
your wounded healer, your liberator.

I hold the keys to your freedom.
My dungeons sit full of treasure.

Remember me and reclaim your lost gifts.
Your fierce knowing. Your timeless wisdom.
Your unflinching eyes. Your fearless voice.
Walk through the fire with me,
and rise rooted once again.

In that moment, facing my Frozen One, I felt caught between a rock and a hard place.

The only way through was to turn towards it with loving presence.

Breathing my energy down into my body, I deepened my awareness. It wasn't easy.

I created sacred space by calling on divine intelligence to partner with me. My guides, beings of love, Source.

Held in the safety of this wisdom field, I explored the tension. Like going down in a lift, I sensed what was underneath each layer, tracking back to the contraction.

The first layer: What would people think of me coming out with this weird stuff? Less than six months before I was a respectable non-profit CEO leading a team of a hundred people. Would I be judged or dismissed?

Dropping deeper, I felt my little 4-year-old self, cringing from the hurt of cutting ridicule and scorn. I held her with tenderness. But there was more.

Deeper still I found the pain of the witch wound. Memories of betrayal, hostility, torn from loved ones, hard-hearted interrogation. Torture. Exile. Death.

Sweat broke out. Tears of sorrow and compassion.

The deepest layer. Heartbreak for everything that had been lost.

How what was passed down from generation to generation now...

...wasn't the collective wisdom of the ages, healing knowledge, natural magic...
...but the protection strategies needed to keep our children safe in such times.

Keep your head down.
Hide your magic.
Don't speak up.
Never draw attention to yourself.
It's not safe to be seen.

Woah! This was it.

Tears streamed down my face with the depth of our hidden collective wounds.

The loss of an entire wisdom-based culture. The pain of hopelessness and defeat.

It took all my presence and empathy to hold space for these feelings rather than be overwhelmed by them.

Each time I access a place inside myself deep and wide enough to hold these collective wounds, to turn towards them and touch them with love...

...I carve stronger foundations to hold a healing space for myself and others.

As a spaceholder who supports changemakers to step into soulful visibility, I'm always my own first client.

When I shift something inside my own system, I bring that transmission to others who are ready to make a similar shift.

This is true for you too.

Whatever medicine path you've walked in your own life, whatever scars you have healed in your own psyche, you offer as a gift to others and the world.

This is an essential part of our sacred work.

This is what it takes to walk the unbound path.

To love the darkness inside back into wholeness.

To disentangle from the toxic lies and very real fears that were embedded in our ancestors' cells and passed on to us.

To reclaim the truth-speaker within, whose eyes see SO clearly they were shamed, attacked and made wrong.

To drop the bars of the cage you were taught to carry in your own hands.

To unshame the inner parts that took on others' projections.

With each step we take along this path, we reclaim our magic. We recover our fierce knowing.

We generate our own safety. We heal the ancient collective wounds.

It's not a journey for the faint of heart. But we don't have to

do it alone.

Find the others who can witness your whole self, who will dance in celebration of your glorious, messy and utterly magical unbound self.

Together we walk each other home.

About Ríonach Aiken

Ríonach Aiken is a Soulful Visibility Guide and Poetry Alchemist™. She overcame decades of debilitating shyness to become a poet, speaker and skilled space-holder for transformation. Her natural magic is to share her depths, touch people's hearts, melt their frozen parts and help them see their own essence. As an energy-sensitive and seer, she can sense energy patterns and shift deep blocks from personal, collective, ancestral and soul levels. Her Poetry Alchemy™ work goes deep fast to switch on your soul wisdom and embody your true essence. Ríonach helps soulful business owners and creatives to clear their visibility blocks, activate their visibility superpowers and actively call in the ones who need their wisdom. Our world needs more visionary voices to become seen, known and valued!

www.rionachaiken.com

ROOTS

By Madeline Myers

The very thing that is our foundation
Keeping us grounded
Yet all others see is them peeking through the dirt
Not the depth
When the spring comes
Bringing the possibilities of new
The branches will sway in the wind freer than before
As the blooms breathe the fresh spring air
The feeling of release engulfs as the worries of the previous
season fade

About Madeline Myers

Madeline Myers is an 18-year-old on her life path to find her soul's purpose. The women in these books inspire her more then she can say, as they move through life's trials with fortitude. While being about to graduate, she is more determined every day to move through life with purpose of growth.

REBIRTH

By Nicola Humber

The forest was still that day. As she walked her usual path, listening, watching, turning over the many thoughts in her head.

The ground was boggy in patches, so she had to tread carefully. Jumping from mound to mound. Finding her way.

A large area of mud appeared. An expanse. Reluctant to turn back and retread the path she'd already taken, she took a big step.

Her foot came down in the mud.

She was stretched.

Uncomfortably.

Between two places.

She brought her other foot to meet the first. Trying to move forward. To gain some momentum.

But that first foot was stuck solid in the mud.

She patted the other foot around. Trying to find firm ground. But everywhere was oozing. She felt herself sinking.

She pushed her second foot down. Attempting to gain some upwards motion. But now both feet were sinking.

Down.

Down.

Slowing but steadily.
She looked around. Surely someone will come?

But no.

No-one was there.

The thick oozing mud reached up above her knees now. And she was still sinking.

She grabbed for her phone. No signal.

Panic rising. Her breath becoming fast and shallow.

Surely she would hit solid ground soon?

Sinking. Up to her thighs now. She started to cry.

Calling out, 'Help! Somebody. Please! I'm sinking.'

No-one came.

Up to her waist. A realisation. Was this it?

She desperately tried to move her legs. Struggling against the thick mud that was encasing her. But no. The force of the earth was too strong.

Chest level. No! Crying more now. The tears flowing uncontrollably. As she sunk faster. The earth inhaling her, sucking her down.

Over her heart, which was beating so fast.

No! 'Please. Someone. Help me!'

The terror. As the mud reached her throat. The unbearable sticky warmth. Paralysed from the neck down. Unable to move. Her arms reaching up. As if trying to catch a lifeline that no-one would throw.

'Please!'

Chin.

'No!'

Lower lip.

It can't be. The feeling of earth against her sensitive skin. Trying to turn her face upwards. Towards the sky. And sinking more quickly. Down. The mud closing over her face. She closed her eyes. The earth encasing her now.

She sank down.

Deeper.

Breathing it in.

Resigned.

Is that it feels like to die? To stop.

Consumed.

Completely.

And still sinking deeper.

The earth took her in.

And she was surprised to still feel aware. Breathing. Being.

Not moving.

Allowing.

Held.

Still.

Darkness.

A strange kind of peace.

The quiet. Silence. Not even the sound of her own heart beating.

And still she sank.

Down.

Under.

Noticing how the earth touched every part of her. How she WAS the earth.

Moulding.

Melding.

A woman-shaped hole.

And then she stopped.

Aware.

Of the throbbing, pulsing of the earth.

She stayed.

Knowing.

Allowing herself to be held.

For how long?

Hours, days, years, eons? She didn't know.

The peace.

Was healing.

Something.
Unknown.

Unspoken.

And then.

Eventually.

After.

An upward force.

Gently.

Lifting.

Like hands.

Pushing.

Her up.

Allowing.

Once more.

Upwards this time.

The earth moving over her body. Falling away.

Up.

Feeling lighter.

And seeing light.

Up.

Through.

And into.

She felt herself push through the surface.

Lying on top.

Spitting out the mud from her mouth.

She felt for her own skin.

Naked. As her clothes had disintegrated.

Only skin.

Dirty.

And beautiful.

She breathed in the air.

Lighter.

Laughter.

And then. She howled.

Pushing herself up to sitting.

Standing.

Strong.

The earth had returned her.

And now. Ready. She walks on.

About Nicola Humber

Nicola Humber is the author of three transformational books, *Heal Your Inner Good Girl*, *UNBOUND* and *Unbound Writing*, and the creator of the #unbound365 journal. She's also the Rebel Leader of The Unbound Press, a soul-led publishing imprint for unbound women.

After playing the archetypal good girl up until her mid-thirties, Nicola left her 'proper' job in finance to retrain as a coach and hypnotherapist and this leap of faith led her to what she does now: activating recovering good girls to embrace their so-called imperfections and shake off the tyranny of 'shoulds,' so they can be their fullest, freest, most magnificent selves.

Nicola helps women to write the book their Unbound Self is calling them to write, whilst growing a community of soul-family readers and clients.

Find out more at: nicolahumber.com

META-MORPHOSIS

By Emma While

When the invitation to contribute to this book came, I leapt immediately. No thought, no hesitation. I just knew I was in.

And then I promptly forgot all about it and got back on with my life.

A life that became ever more frequently punctuated with reminders to submit my piece.

And I found I had absolutely no clue whatsoever what to write. What to write about. How to write about it. Nothing.

And the harder I tried to work out what on earth I was going to submit, the deeper and darker and fuller of tumbleweed the hole inside my head where the answer should have been became.

Then one day, as I was innocently making my way to bed (nearly two hours past my bedtime because I have apparently become so unbound I have even unbound myself from my own self-imposed boundaries and good habits), the answer very rudely shoved itself right in front of my face. Forcing me to abort my bedtime plans and to set about writing instead. I say, 'one day,' that day is in fact TOday and you are in fact joining me perched on the edge of my bed, in the dark, in my pyjamas as I fervently type into my phone before I forget the whole thing entirely, wishing I had socks on because my toes are already getting cold.

Back to the story...For no apparent reason I was presented

with the memory of a similar brain fart moment from a few years ago. At that time, I'd just finished a year-long medicine woman mentorship and I'd been 'invited' to prepare and share my reflections on the journey.

I found I had nothing at all to say. Or rather, I didn't know what I 'should' say or how to say it.

I felt like I didn't understand the question even.

Which made me feel utterly stupid since it was an entirely simple and straightforward question by all accounts.

And that made me incredibly angry. In fact, the more I pondered the assignment the more I found myself boiling with rage and violent frustration. And wishing actual bodily harm on the person who'd set it.

The moment I was due to present my reflections drew ever nearer and my fury grew ever more fiery. I briefly considered inventing some obscure illness and then going into hiding but knew deep down I just had to get on and write something.

I had a cold shower. I danced and stomped. I shouted and screamed and then I made myself start typing. Anything to start with.

'I fucking hate this stupid bastarding question and I bloody well hate the arsehole that set it. I don't know what they want! I don't know what I'm supposed to say!' I bashed into the keyboard.

I cried and blew big hot bubbles of snot all over the screen as I continued to attack the keys as if it was their fault I was in this predicament.

Until a strange kind of peace washed over me and I found I was actually answering the thing. There I was, typing out my reflections. I hadn't known those were my reflections up until that point, but they were appearing on the screen in front of me and I was the one making them appear there. And they felt just right.

So what the hell had been the problem in the first sodding place then?

'I don't know what they want. I don't know what I'm supposed to say.'

That had been the problem.

Hidden inside those two sentences was a lifetime of fear.

Fear of getting it wrong
Of looking stupid.
Of missing the mark.
Of being different or standing out.
Of disapproval.
Of not living up to expectation.
Of letting other people down
Or letting myself down.
Of saying the wrong thing or something not as good as what everyone else was going to say.

Fear that I'd be found out for being inadequate. Fear that I'd done that whole year and hadn't really grown or learnt anything at all.

That I was a joke.
An also-ran.
A fraud.
A silly little girl playing at being a grown up but getting it all

wrong after all.

Hidden inside those two sentences was the misguided notion that there even WAS a right answer. And that that answer would, could and should be found in and with my head.

Hidden inside those two sentences was the notion of 'them' and 'me' and the clear indication that I had placed all power and knowing out there with 'them' rather than inside me and not only that, but that it was now my duty to live up to whatever that 'them' thought I was 'supposed' to be doing.

I was bound. By those two sentences and by the fear and the powerlessness and the 'shoulding' and the smallness they contained and by the power all of that held over me.

And here I was doing it again.

The same subconscious fears and doubts were binding me even as I tried to write about walking the unbound path.

Not knowing what others have contributed to this book, nor what The Unbound Press are expecting or even want, had been blocking me from letting myself write anything in case I got it 'wrong'…even though the brief clearly said, 'you can't get this wrong!'

I'd been wanting somebody else to go first. Or a clue, a leg up.

But I didn't need one.

I just needed to let those bloody binds go.

Because on the unbound path there IS no wrong. No supposed to. The unbound path gives precisely no fucks

about expectation or shoulds or what anyone else thinks or does.

So, I let go. Without the swearing and the snot this time. I let go of 'them' and sank into 'me.'

And I wrote this.

And there you have it, my slightly meta tale from the ever-unfolding unbound path.

About Emma While

Emma While is a mother, an early years and adult learning specialist, positive psychology geek, lover of squirrels, wild swimmer, NLP Practitioner, mindfulness teacher, writer and owner of Courage & Chamomile (purveyors of transformational coaching for mums since 2016).

Since unbinding herself free of society's expectations of her (as well as those she had foisted upon herself), Emma has been passionate about empowering other mums to do the same…

…to believe in and become their FULL and unapologetic selves, beyond the identity of 'mum' or any other roles they play. To let go of the shame, the guilt, the rules, the shoulds and the should nots, the 'I can'ts' and 'I have tos.' To break the cycles and the patterns, to consciously curate the passionate, exciting and fulfilling life they both desire and deserve, and dream into being a future fit for the next generation we're raising.

Instagram: @courageandchamomile

ẆHAT'S NEXT?

Want to access resources to help you walk your own unbound path?

Head to: nicolahumber.com/unbound-path

Want to be part of the next volume of Tales from the Unbound Path?

Find out more at: theunboundpress.com/tales-from-the-unbound-path

Want to find out more about becoming an author with The Unbound Press?

Head to: theunboundpress.com

Printed in Great Britain
by Amazon

26089714R00073